STEVE MCCURRY

Anthony Bannon

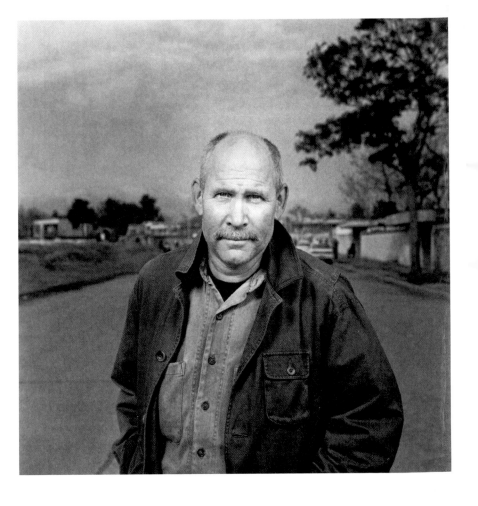

For Steve McCurry, photographs are not so much about art as about creating a record, or telling a story, or holding on to a memory about the way things used to be. For him, creating photographs is a straightforward matter. Yes, patience is involved, and keen looking, and careful planning. 'But it is simple,' McCurry insists. 'Really.'

McCurry's gift as an artist is his ability to make the complex seem easy through photography. His pictures get to the heart of the matter. They have served as icons of understanding about the changing face of Asia, about the first Gulf War, and about the conflicted tapestry of Afghanistan. McCurry's images reveal what it was like to have been there, in that moment, with that person, witness to the drama and to the poetry of colours and forms – gifts of seeing well that occur every day. McCurry's pictures propose a new vision. They ask, as McCurry asks himself as a photographer, that you look carefully, mindfully attentive to what is there before you. This is the special and unique value of his pictures. And much as McCurry tries in conversation to avoid the subject, his photographs, often used as illustrations in the press, have as a result earned a place in the history of art in photography.

Few people are likely to know the name Sharbat Gula, but most will know her description – 'the green-eyed Afghan girl'. McCurry's picture of the haunting refugee, taken in 1984 for *National Geographic* (page 39), established her presence in an extended human family, a family known through the international languages of social concern and art. The photograph, alongside others of war-torn Afghanistan, also established McCurry as a major international documentary photographer. As vibrant, colourful, exotic, searing or contemplative as his images might be, McCurry's photographs first of all state their allegiance to the great documentary tradition of photographic truth telling.

'What I respond to is the little street urchin in Tibet, who obviously comes from a ve[ry] poor family,' McCurry says, describing a picture he made in Shigatse in Tibet in 20[?] (page 115). 'She has a Chinese coat on and seems very proud of it. She has dign[ity] She looks a little bit happy. And she doesn't seem aware of how politically poigna[nt] it appears to be wearing that coat in the middle of the afternoon in this alleyw[ay] particularly after all that has happened in the conflict between Tibet and Chin[a] I don't want the colour to interfere. I don't want the picture to be about colour. I wa[nt] the picture to be about this little girl in Tibet with the Chinese coat.'

McCurry's photographs from around the world locate the discrepancies betwee[n] what his viewers expect to see and what the artist, in fact, discovers within th[e] uniqueness of the moment — what he has called the 'right now only offered onc[e]' moment. While still a student at Pennsylvania State University in 1972, he foun[d] a man sleeping on the street in front of a furniture store window in Mexico City (pag[e] 17). Behind the glass of the window, the store had established a living room wit[h] a luxurious couch. The window was like the proscenium of a theatre stage, an openin[g] onto another world, offering in a separate space an idealized view of things. But re[al] life insists on its own reality, right there in the foreground in front of the stage, in th[e] area — our area — reserved for the audience.

Almost thirty years later, McCurry discovered a real-life tragedy taking place withi[n] the frame of another proscenium, upon another stage. Looking through a ver[y] different window — this one with violently shattered glass, darkened by tragedy[—] McCurry located a lone fireman hunched up on a ladder in the shell of what wa[s] once the World Trade Center (pages 116–117). These contradictory, puzzling an[d] disturbing pictures are evidence of some of the small stories of humankind. They ar[e] an encounter the photographer has witnessed, a moment that stands in for moment[s]

...e could not experience – often from a far different place and culture. They are small ...ces from recent history that are likely to stand the test of time and argue on behalf ... the sometimes difficult realizations we extract from a particular situation. These ...oments recorded through the fidelity of a photograph become memories of our ...ulture and are lessons that we use to create our own understanding of history.

...e search for moments like these, sufficiently strong and vivid to command memory ...nd convey meaning, is what drew McCurry to photography. Born in Philadelphia in ...950, McCurry had studied History and Cinematography at the College of Arts and ...rchitecture, Pennsylvania State University. On graduating, he took a job on *Today's* ...ost, the newspaper in King of Prussia, Pennsylvania, a suburb of McCurry's native ...ty. Four years later, in February 1978, he left. With his girlfriend Lauren Stockbower, ...ho was also a photographer on the newspaper, he set his sights upon the world. As ... freelance photographer, his aim was to create geopolitical features for magazines. ...e geopolitical part happened easily, travelling through Nepal and India and living ...n little more than $100 a week. The magazine work came more slowly, at first in the ...orm of small stories in magazines for young people like *Scholastic*.

...n May 1979, however, an unexpected opportunity opened up in nearby Pakistan. ...cCurry seized it. 'I had wandered up into the North West Frontier Province in ...akistan, and bumped into a couple of Afghan refugees who told me that a war was ...aging in Afghanistan. They could see that I was a photographer and thought I could ...elp give them some exposure and tell their story to the world.'

...o a connection was made. In a rundown border hotel, McCurry was to meet a band ...f Mujahadeen freedom fighters. They dressed the young photographer in an old ...halwar kameez and sneaked him across the border into their country to observe the

fight against the Soviet Union, waged far away from most international press scrutiny. 'They said they were going to come and get me at 6 am. I lay there, petrified, hoping that they would forget, or that it would be cancelled. They were an hour late. Out of pride, I didn't back down. I went with them, but I was very nervous, thinking: "What the hell are you doing? What have you got yourself into? You don't know who these people are. They could rob you; they could kill you. And you're going into a country illegally." But once I had got in there, day by day I started to feel more and more comfortable with it ... I wanted to be where the action was.'

McCurry accompanied the Mujahadeen back to their village from Pakistan, where they had been reviewing strategies with their commanders and restocking their ammunition and medical supplies. He shared food and water with them, prayed with them, and attended funerals for the many killed in battle. Communication was difficult, as McCurry did not speak the local Pushtu, so the only common language (of which he knew but a little) was Hindi. Every village was under siege so they had to travel covertly. They would rise before dawn and walk all day, across mountainous terrain that was frequently too difficult for horses or camels, regularly under fire from government artillery. Cold and hungry, but desperate to avoid detection by the helicopters that constantly patrolled overhead, they would often walk all night too, taking extra care to avoid the deadly mines that lined the trail.

After several weeks, he decided it was time to leave. He sewed his exposed film into his clothing and slipped out across the border, back into Pakistan. He sent the film to his sister, Bonnie V'Soske, then an elementary schoolteacher in Upper Darby, Pennsylvania, who took the initiative of sending it to the Associated Press and to various publications. In September 1979, *The New York Times* bought the pictures of Afghan fighters watching a Russian convoy (page 19). As one of the few Western

hotographers with images of the Afghan war, work now came to McCurry, notably ssignments from both *Time* magazine and the American edition of *Geo* magazine. s the situation escalated in December 1979, and the Soviets began a huge military irlift into Kabul, the young photographer's work was in even greater demand. To cCurry, a student of history, the passion of the Afghans, who were fighting for heir country, felt like the American Civil War. It was a question of life and death and easeless struggle. The intense feeling took hold of McCurry. He has returned to fghanistan some twenty-five times since 1979. The nation has changed his life.

fter the success of this body of work, opportunities rolled in, with features for nagazines as diverse as *American Photography* and *Paris Match*. In January Arnold rapkin, picture editor at *Time* magazine, called McCurry, offering assignments worldwide. And then that summer, in July 1980, a little more than six months after the publication of the Afghan freedom fighters in *The New York Times*, another turning point arrived. McCurry called on Bob Gilka, the legendary Director of Photography at *National Geographic*, and Gilka offered him an assignment, which began a relationship that has continued and has remained central to McCurry's career. Without knowing it, Gilka also gave McCurry colour. In those first freelance years after leaving *Today's Post*, McCurry was already shooting mainly in colour, but given the relationship with *Geographic*, his palette blossomed.

Working with *Geographic* was major. The magazine gave me the time to develop a story, to dig deep into the subject rather than simply reacting, caught up in a lock-step situation.' Taking pictures truly became a way of telling a story. It was no longer just a case of taking one or two pictures that would illustrate, or suggest, a story. Now, McCurry could take all the pictures and tell the whole story. With his colleagues at the magazine, McCurry focused on the journalistic values of what he

was doing. 'Our work was about the subject, about content. We would talk about art too, and about photography as a craft, but taking pictures is above all about telling a story.'

Bob Gilka was a powerful, benevolent mentor, and he saw the range of work that McCurry could offer, including stories away from the hot spots of international conflict where he had made his reputation. McCurry proposed features about people in relation to the elements, to drought and monsoon, and sequences of daily life far removed from warfare. In 1980, his coverage of the war in Afghanistan for *Time* magazine won him the Robert Capa Gold Medal Award, for 'the best published photographic reporting from abroad requiring exceptional courage and enterprise'. McCurry's work published in *National Geographic* also received accolades on a yearly basis: in 1985, for example, he received the National Press Photographers Association Magazine Photographer of the Year Award, four first place awards in the World Press Photographers competition in Nature and Daily Life categories, and the Olivier Rebbot Memorial Award, which he also received the following year for work carried out in the Philippines.

It was for *National Geographic* that McCurry had created the epochal image of 'the Afghan girl' who, at the age of twelve, captured the heart of the world. This surely was another turning point, in his life as well as in his profession. McCurry found the girl in the Nasir Bagh refugee camp near Peshawar, Pakistan, close to the Afghanistan border, not far from the place where he had first entered into Afghanistan with the band of Mujahadeen. McCurry vividly remembers the first time he saw her. There was a small tent that was used as a classroom for girls. McCurry was curious; he looked into the tent. 'I noticed the Afghan girl in a corner, and I just remember that look, that haunted look. She had these amazing eyes.' She was one of three. He took pictures

f each of the girls but out of that series of exposures, one image endures as the image that captured that particular moment. It is one of the most striking portraits in the history of photography. How does that happen? How is it that the world selects a certain picture out of millions that are made each month? 'It's like when stars line up,' laughs McCurry.

Photography and the genre of portraiture have enjoyed a long and fruitful relationship. From the beginning of depiction, the portrait has invited its audience to recognize the identity of the subject and then to remember. Through the likeness, the viewer can meet a stranger and cherish a loved one. We connect, eye to eye, with others who live in places and engage in behaviour we may not have imagined. 'Most of my images are grounded in people,' McCurry says, 'and I try to convey what it is like to be that person, a person caught in a broader landscape that I guess you'd call the human condition.' His desire, he makes clear, is to show the 'human connection between all of us'.

At its most basic, the face – and its portrait – is the site of the senses: vision, smell and taste are centred here. It is through the face that one gathers and distributes information. We send out an idea through speech or gesture, and then we look and listen to confirm that the message sent has been received and understood. We check for clues from the person with whom we are speaking, puzzling that other face to register through a recurring smile or discerning eye if our message has made sense.

The portrait is read with similar purpose and intensity; we search it for clues through which we might know the experience and conditions of the person shown, and perhaps draw from it conclusions about ourselves. It was once said that the face reveals what words may hide. The face, McCurry agrees, provides a wordless

entry to the truths of the matter, and perhaps to the soul. A good picture taps int 'some archetype of human connection,' he says. In a good picture, 'the soul will drif up into view'.

McCurry's photograph of the Afghan girl, orphaned a year earlier when her villag was bombed and her parents killed, offers signs for multiple readings of her difficu life. With other villagers, the child had made a two-week trek through mountains t the refugee camp where McCurry found her. To his camera, she appears much olde than her years, her face scarred and dirty, her shawl ripped, her head cautiousl positioned. Her eyes provide a strong green contrast to the deep red of her artfull draped shawl, and they penetrate the distance between her place and her time an that of the viewer. She connects, and through her connections in the ensuing year she has attracted proposals for adoption and of marriage as well as gifts for th education of young Afghan women. Around the world, those who saw her likenes were moved to open themselves up toward another human being and the needs o others. The picture is the emblem of McCurry's career and is consistent with hi objective as a documentary photographer: to depict through the lives of other concerns that are universal and comment on the human condition.

McCurry points to the achievements of Walker Evans, Dorothea Lange, André Kertész and Henri Cartier-Bresson. 'If they are called documentary photographers, I woul be proud to be called a documentary photographer.' Their photography, like hi own, is located in the events of life, not posed or set up. 'I want to be a part of tradition of photography that depicts the world as it is, that portrays humanity a it is, and documents world events.' That is also the tradition of the Magnum agency established in 1947 to provide 'a credible witness to life'. Nominated for membership by Eve Arnold and René Burri, McCurry joined Magnum Photos in 1986, which proved

o be another turning point. 'It was the first agency to promote the photographer's rights over and above those of the magazine editor, and it has established itself as a legendary force in photography. I want to associate with people who work at a high level, both professionally and ethically.'

McCurry often visited Cartier-Bresson, who was one of the founders of the Magnum cooperative. Looking back on Cartier-Bresson's work, McCurry says 'I think he was just having fun. He was out observing how crazy this world is that we live in, or how wonderful it is, or how amazing it is; really, what kind of miracle it is.' For McCurry, the world is quite enough. It isn't necessary to try to make more of it. At the beginning of the day, he does not put an artist's hat on. 'Let me go out and just observe life, people's behaviour, how they decorate themselves, or decorate their homes.' For McCurry, there are no borders, no places that are off limits. 'You go in and a whole world opens up and you are often surprised that it is not the way you imagined it at all. There are nice people, working people, interesting people doing interesting things.' McCurry found the Afghan girl by wandering away from a situation he found compromising. The writer he had accompanied was arguing with the administration personnel of the refugee camp they were visiting, and McCurry did not want to be part of it. In those situations, he reflects, good things often happen when 'you wander off the path. When you are wandering with a camera, images are almost instantaneous … You can't think too long because the moment will be lost. There's just this sort of gut feeling. And you follow it.'

What is it that finally compels the photographer's attention and compels the viewer to notice and remember? 'It's a mystery. It's magic. It's an enigma … and yet, I often feel, it's so obvious,' says McCurry. 'People always seem to be perplexed. "How do you make a good picture?" But to me it is so simple. It is not complicated. It is not difficult.

It is just very natural … you grab a camera and walk down the street and develop the film. It is all pretty straightforward.'

McCurry is not being disingenuous. His ability to discover vibrant colour and dramatic composition are the skills of a practised artist, similar to the improvisational skills of an accomplished musician. 'Light, colour, composition – that's the beginning. You need those elements as ingredients. The challenging part is to make a picture that has some meaning.'

The art historian Geoffrey Batchen has argued that photography came into the world as a medium created for at least four tasks: to aid the assembly of knowledge; to still time against its ravages; to represent and memorialize; to catalogue nature and organize space. If photography had a mission statement, those four principles would be its pillars. McCurry's work is in accordance with the mission. The photograph is a special kind of mark, indelible, direct. It traces powerful events. It stands in a unique way for whatever it represents. Had we known him, McCurry's photographic record of the naked body of a young Iraqi soldier (page 47) would tempt us to call and remember him by name. It would be Mohammed that we had seen, not a photograph of Mohammed.

Still, the photograph is a small, venial and fairly fragile thing. It can fade easily; it crimps and tears. We loose them. Printed out onto newsprint, the photograph can end ignobly, blowing on the wind, or wrapping fish. Just the same, the photograph is far more than a mere representation. We invest it with a near magical ability to stand in for whatever it shows, so that a tiny picture, like McCurry's image of that Iraqi soldier from the first Gulf War, still takes our breath away a decade later. The searing memory of this dead man – like the dead of the American Civil War, or any of the

myriad other dead from other wars that photographs have documented — continues to live through his image. For we know that the photographers who captured the sight that day, which we now hold framed in a picture, could have reached out back then to touch the dead soldier before them. The image holds that precious experience and carries it into the present, representing something that would not otherwise be available, except through the photograph.

McCurry selects and frames what he sees. Through the process of doing this he turns what he saw at a precise moment into something intensely memorable, something that will resonate in those who experience his photographs in the future. In this way, McCurry and those who see his work are joined with the subjects of his images in a creative collaboration, a bond which, when it is successful, extends far beyond the surface of his photographs, profoundly affecting those who view them and perhaps even changing their opinions of the world.

McCurry has taken his audience to distant and dangerous places, places of wonder and awe. His work presents us with vivid descriptions of different lands and their people. His photographs encourage the viewer's own senses of virtual exploration and discovery, initiating a process of considering, describing, and naming the unknown.

Yet McCurry is aware that by its very nature the photograph can be an imposition, a rude interruption of time that otherwise flies on, freely. His work tells a story. But part of it is outside the frame of the picture. Afghanistan, for instance, was still a dangerous place in 1992. Tribal factions remained at war with one another. Mercenaries and criminals frequently took hostages for profit or for political opportunity. McCurry remembers travelling with a group of United Nations staffers, who were teaching residents how to recognize the dangers of active land mines. The group visited Herat,

a town that had been levelled by war. Yet in the red glow of a sunset, a cluster of people gathered at a fire, finding community, if not family, amid the destruction (page 53). The dangers are not present in the frame; instead, one finds a declaration of eternal values. And in daylight, days later in Kandahar (page 51), men, who were no strangers to the danger it posed, built a kiln much as they might have done a thousand years ago.

McCurry's curiosity has taken him around the globe, but his focus has been on Asia, a vision celebrated in *South Southeast* (2000), a dramatic book that won the Picture of the Year book award, amongst others. Solo museum and gallery exhibitions worldwide followed, culminating in 2003 with a touring exhibition, *Face of Asia* organized by George Eastman House, International Museum of Photography and Film in Rochester, New York. His subsequent books (*Sanctuary: The Temples of Angkor* 2002; *The Path to Buddha: A Tibetan Pilgrimage*, 2003; *Looking East*, 2006; *In the Shadow of Mountains*, 2007; *The Unguarded Moment*, 2009; *Steve McCurry: The Iconic Photographs*, 2011) chronicle his continuing affections for Asia, and a new peak of activity and recognition. He was honoured by the United Nations International Photographic Council, recognized as Photographer of the Year by *American Photo Magazine*, granted an honorary doctorate by Fairleigh Dickinson University in New Jersey, and cited by the University of California, Pennsylvania State University and the Lucie Award committee — all in the first years of the twenty-first century. His work has been included in major international museum collections, including George Eastman House (Rochester, New York), the International Center of Photography (New York City), Philadelphia Museum of Art, Houston Museum of Modern Art and Tokyo Museum of Modern Art. And in 2003, a film made by Lawrence Cumbo with McCurry, documenting the quest to trace Sharbat Gula, won the Gold Prize for Documentary at the New York Film Festival.

Throughout the adulation, McCurry's vision as a photographer has sharpened. It becomes clear that for McCurry there is now an additional impulse to photograph. He acknowledges that his pictures have been recording 'something that I think I want to remember – almost like a diary or a notebook.' The more he looks, the longer he records and the clearer it becomes that he is taking the last look at so much that stands for cultural identity around the world, from amulets to architecture. 'What is fragile, subtle, beautiful and sublime is going to disappear. It has already. It is more common now to see a baseball hat and a Chicago Bulls jersey than traditional clothing in nearly every place I travel.'

Primary colour, dramatic light and direct composition – the elements which many insist are McCurry's pictorial trademarks – are simple supports, raw material, the building blocks for the meaning his pictures are made to convey. His photographs are a response to people and the substance of their lives: their triumphs and suffering; the way they make their food and set their tables. This is the focus of his efforts. And at the end of the day, this is where his artistry resides. 'What I want to say is, this is what we were like as a people, and this is how we lived. These are the places. And here are some of the faces.'

Street Scene, Mexico City, Mexico, 1972. The transparent barrier between a fau living room and the reality of the street heightens the difficult counterpoint c commercial plenty versus homeless need. Only a window separates the cruel life of poverty from a comfortable place to sleep. At just 22 years old, McCurry utilize in this photograph the visual tools that have marked his career to make visible a concerned perspective for telling a story in a direct, dramatic and revealing manner.

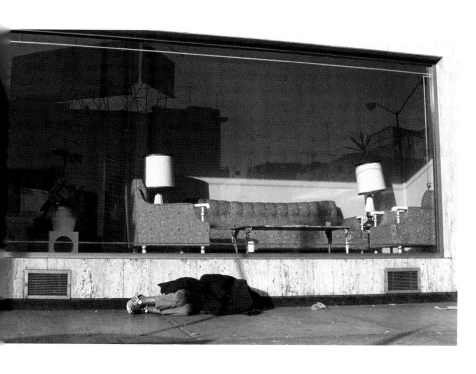

Mujahadeen Fighters, Nuristan, Afghanistan, 1979. After this photograph was pub-lished in *The New York Times* (in a vertical format), McCurry's career took off. It publication identified McCurry as a photographer with inside knowledge and contact as the conflict between the Soviet Union and Afghan nationals expanded. The imag also heralded the photographer's intense, poetic approach to telling stories with a economy of means, strategically employing composition, light, and space as narrativ tools. Here, for instance, the story is more powerfully told *without* seeing the Russia convoy the Mujahadeen fighters are so intensely observing, leaving the threat of thei presence in mist outside the frame.

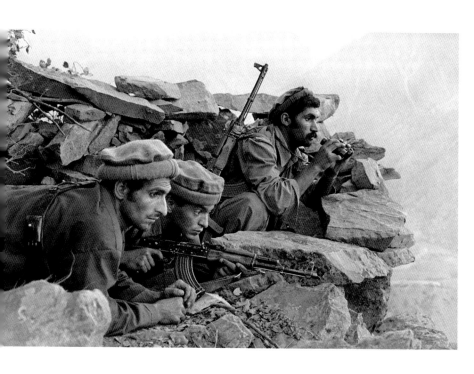

Farmer, Balochistan, Pakistan, 1980. Moments before the photograph was made this farmer was working his field, separating the chaff from the wheat. The detail in the strands of finely wrapped fabric in his turban and the sympathetic pattern in his vest caught McCurry's eye, a compelling lyric within a narrow band of muted colour. As the farmer leaned upon his staff, McCurry noticed its corresponding texture and hue, and then when he grasped the staff and revealed the bright punctuation of his ring, McCurry knew he had a picture. Now, years later, McCurry reflects that the photograph can no longer be made in Pakistan. 'It is very different today,' he notes.

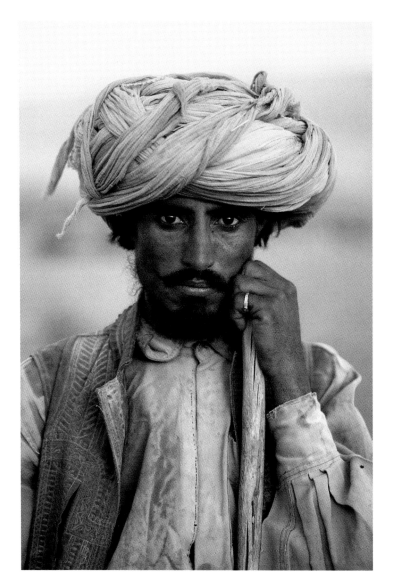

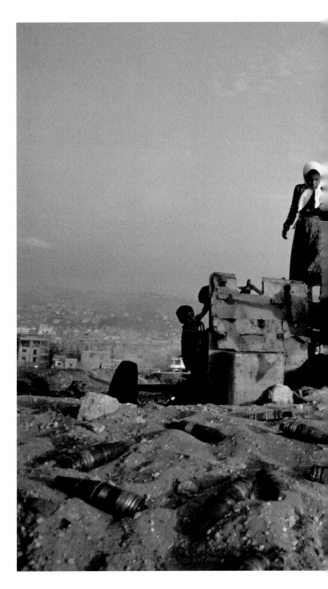

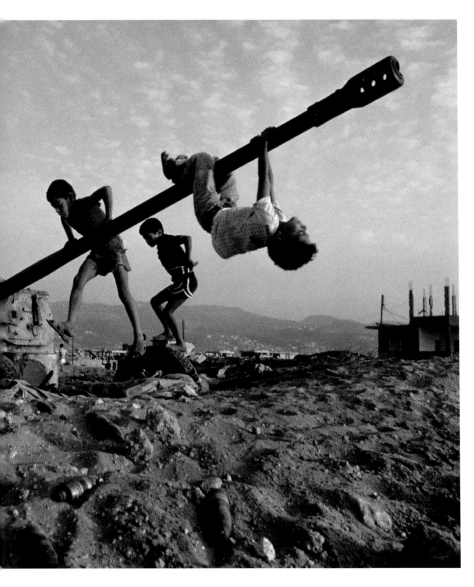

(previous page) Children Playing, near Beirut, Lebanon, 1982. The irony of children playing on an abandoned tank, as if it were a 'jungle gym' in a schoolyard, recalls the unfortunate irony of a man sleeping on the street in front of a couch in a Mexico City furniture store display window ten years earlier (page 17). This rhetoric of contrast is a signature of McCurry's work — declarative, bold, unflinchingly clear. In this photograph, the scene is heightened by the explosive potential of the shells at the children's feet.

Train Station Platform, Old Delhi, India, 1983. The rising sun spills into the rake of a skewed vanishing point, and the romance of rail travel unfolds into another day. McCurry takes on a scene already made romantic by many other photographers in train stations around the world. He heightens the typically dark allure of the scene with a vibrant sun, extended shadows, and the pattern of repeating cuts of light and shade. The picture is one of what McCurry calls his 'notebook entries', made for a book, *The Imperial Way*, which he created with the writer Paul Theroux.

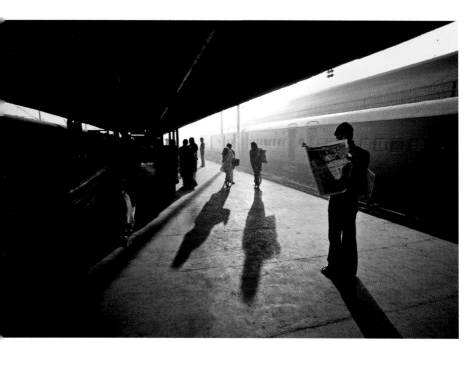

Dust Storm, Rajasthan, India, 1983. McCurry cites this picture in the workshops he holds around the world. The lesson, he says, is this: 'You can't get hung up on what you think your "real" destination is. The journey is just as important.' McCurry made this picture while on a highway heading somewhere else in India. He had been stopped by a severe dust storm. Looking out of his car windows, he saw these road workers near Rajasthan, huddled together against the elements. 'You have to be prepared and open to what you are seeing along the way. And then to stop and make the picture.'

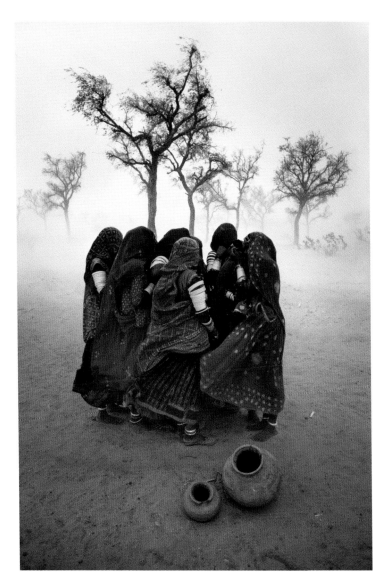

Taj and Train, Agra, India, 1983. This photograph recorded in 1983 the contras
between a mighty technology – the steam locomotive – and the transcendent aesthetic
of the Taj Mahal, with its light-reflecting surface. The steam engine, once an important
symbol of Indian national culture, is now a thing of the past. So in addition to staging
a powerful rhetoric, McCurry's photograph captures a lost moment in culture. Ever
the tracks near the Taj Mahal have now been removed. The character of McCurry's
work, then, lies in the power of its record *and* its rhetoric. The photograph of engine
set against architectural splendour holds fast an idea – a way of thinking about
contrast and culture that can be carried forward to other images in other times.

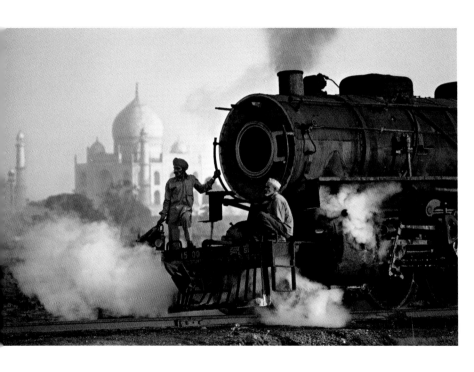

Chandni Chowk, Old Delhi, India, 1983. Life goes on, in spite of and because of the monsoon. That is why McCurry loves this weather. His award-winning book *Monsoon* (1988) extols the vigour of extreme climate. It requires a special acceptance and discipline. The street vendor shows up to make his sales. Men head off to work. They make accommodations. The palette is muted. But the gift of daily life, like a shock o white and the vivid presence of the colour red, shoots through the grey, rainy day.

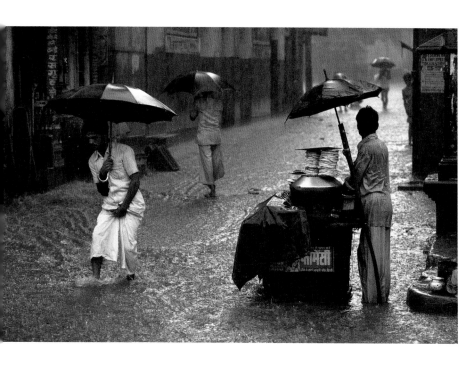

Dog caught in a Monsoon, Porbandar, India, 1983. A wry humour underpins this bittersweet depiction of man's best friend. This situation rings true for all of us, not only for dogs. One can imagine that the dog was barking to go outside – but once out there saw there was nowhere to go. 'It is clear that the dog's predicament is that he's trapped,' recollects McCurry. 'The street is flooded, the door is shut and he is stuck on that tiny piece of concrete, waiting to be let back in. Of course, who knows what that dog is thinking …'

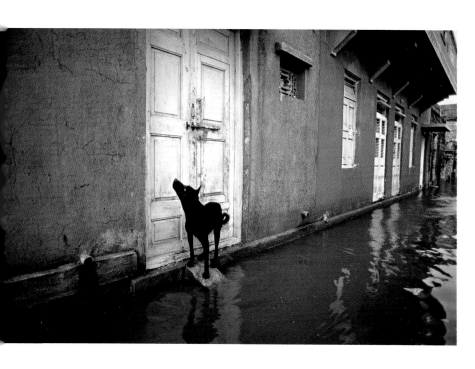

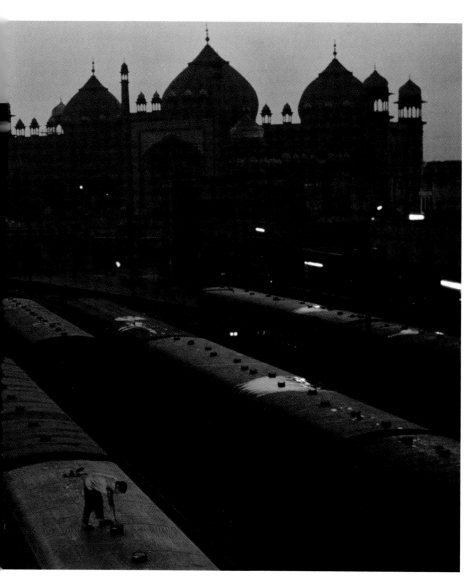

(previous page) Train Station, Agra, India, 1983. McCurry brings together in th unifying glow of the setting sun the contrast between old and new, as betwee eternal values and change. This photographic 'golden hour' is a time whe McCurry often works. Hard edges are softened and a beautifying tone suffuse a scene. The stream of trains and passengers pushes against the spiritual presence c a large mosque. And McCurry heightens the point he is making by locating a vigorou design within the scene that radiates outward from the upper left of the image.

Tailor in Monsoon, Porbandar, India, 1983. McCurry has the artistry to free photo graphy from its anchor in the particular event, in the often mundane facts o occurrence at such and such a precise time and place. There is no question tha the photograph has a distinct power in proving its point, in revealing precise detail It usually has a more difficult time creating principles, moving from the discrete instance to the more general application. McCurry makes photographs that make this leap. This picture depicts more than the surrealism of a man up to his neck in water carrying a sewing machine. It is also a picture about grace in a time of trouble, about acceptance, and about endurance. This is likely to be neither the first monsoon the smiling man has experienced, nor the last.

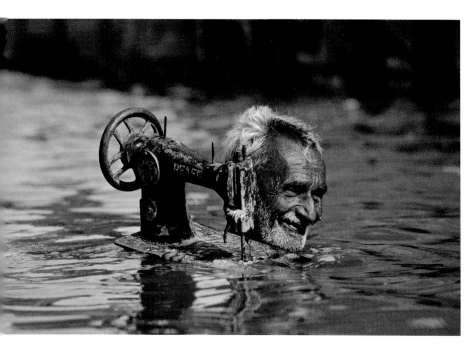

Afghan Girl, near Peshawar, Pakistan, 1984. The green-eyed Afghan girl became a symbol in the late twentieth century of strength in the face of hardship. Her tattered robe and dirt-smudged face have summoned compassion from around the world; and her beauty has been unforgettable. The clear, strong green of her eyes encouraged a bridge between her world and the West. And likely more than any other image, hers has served as an international emblem for a difficult era and a troubled nation.

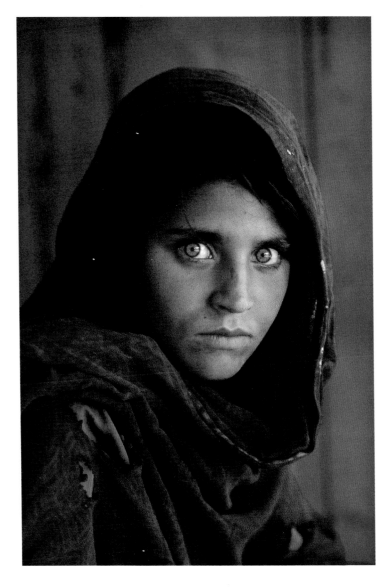

Gypsy Boy, Marseilles, France, 1988. Whenever interviewed, McCurry downplays the artistry of his pictures, insisting upon the importance of the subject matter over and above any aesthetic devices he employs. And surely here, the quiet strength of the connection made with this youngster is the central focus. But the memorable power of the picture is heightened by the strong vertical repetition behind the boy — extended on the left by the vertical patterns made by the shadow, doorways and wall. And then we notice the barrenness of the migrant gypsy household, the torn wallpaper, and the dog in the doorway. The dog is a gift, one of the grace notes of photography, which pulls in life the way it is.

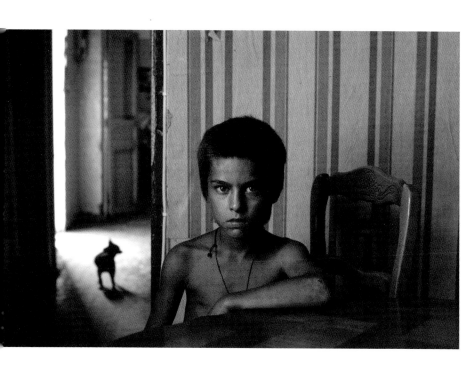

Kitchen Interior, Shigatse, Tibet, 1989. A Tibetan family sits around a fire that warms their morning tea. Through the smoke of their living space, the light from a window creates a slice of time. The mother churns yak butter, as her daughter shyly hopes McCurry will include her in the picture. At first sight a straightforward image of rural Tibetan life, the picture continues to reveal itself as one about the light that so dramatically illuminates and preserves a glimpse of life in a culture that is rapidly changing.

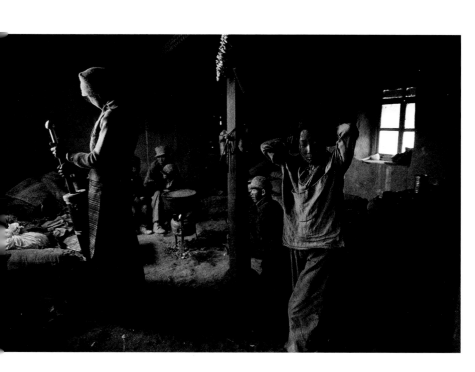

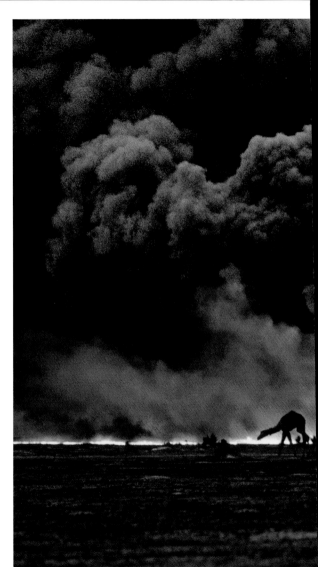

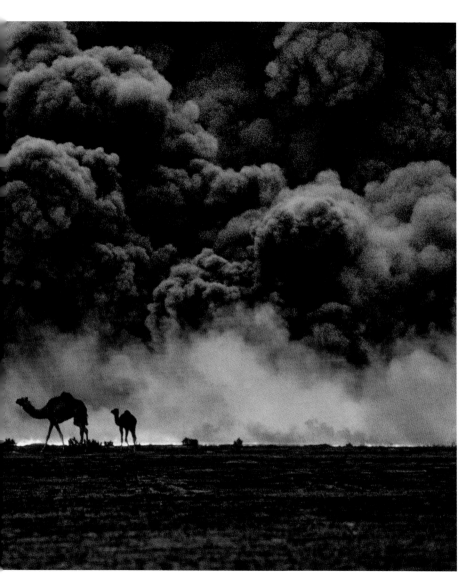

(previous page) Camels and Oil Fire, Kuwait, 1991. The first Gulf War taught us a new lesson in unconventional conflict. Saddam Hussein's army filled the skies of southern Kuwait with black, poignant smoke from the burning oil lines. It was a powerful, debilitating symbol. And there was another. McCurry, who was covering the war, saw camels running in terror from the fires. Both images — whether of the fires or of the animals — were powerful representations of the chaos of that time. Central to McCurry's reputation as a journalist is his discipline to wait, and to search, and then to recognize the most telling image. The juxtaposition of the fire and smoke and the camels running amok creates an icon of that war.

Dead Soldier, Gulf War, Kuwait, 1991. It was like Armageddon. The midday sun was extinguished. Fires burned at the horizon. Burnt oil filled the lungs. The oil rained down from the sky and coated everything indiscriminately, whether dead soldiers or the abandoned machines of war that littered the battlefield, or those still living. In this horror, death had little dignity. There was not even time to bury the dead. Little redeems this soldier, his clothes burned from his body, his company in retreat, the abandoned burnt shell of his tank behind him.

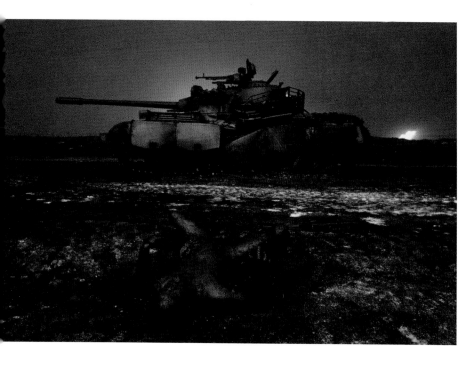

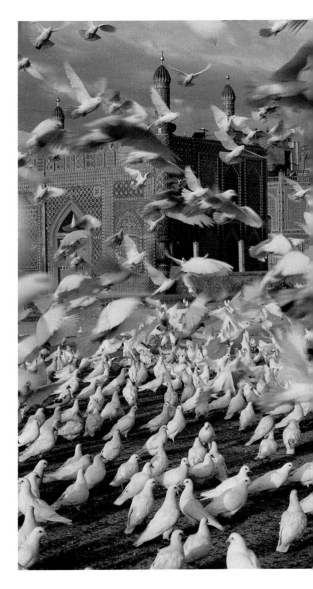

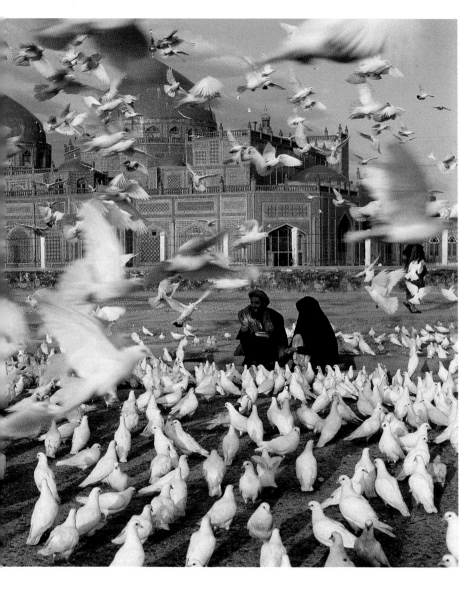

(previous page) **Blue Mosque, Mazar-e Sharif, Afghanistan, 1992.** The white dove are a tourist attraction for Afghans. They are fed and cared for by travellers – t traders and farmers who come to market, and by residents of the northern regio who come to the city to pray at the large mosque. In a country not given to leisur travel, the doves provide a symbol of peace.

Rebuilding a Kiln, Kandahar, Afghanistan, 1992. McCurry returns time after time t Afghanistan because it is a country that demands survival skills from those who visi as well as from its citizens. Rugged, sometimes wild, it still maintains the dignity o centuries-old traditions, and thereby offers a glimpse into the way life was lived ir the past. The rebuilding of this kiln provides evidence of historic process and with it the social interactions that are the signs of community.

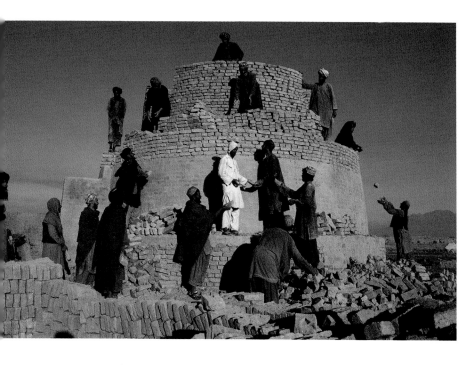

Bombed Townscape, Herat, Afghanistan, 1992. It looked like Dresden after World War II, McCurry thought, staggered by the total devastation. But the war with the Soviet Union had ended, and once stability was restored to their city, vanguards of families from Herat returned to their homes, eager to rebuild. Family members gathered, cleared the rubble, prepared food, kept warm, and redeveloped a community.

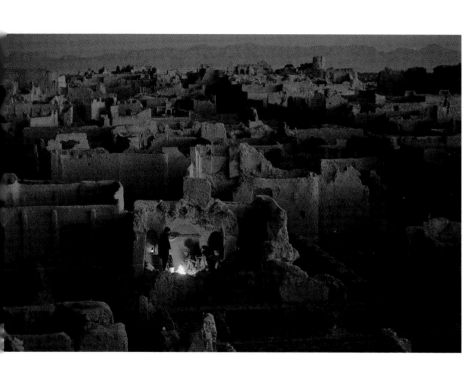

Asylum, Kabul, Afghanistan, 1992. Life in this asylum is 'about as bad as it gets,' McCurry reported. With little food, medicine and supervision, there was virtually no hope for return to a healthy life. McCurry noticed that this man, unlike most in the asylum, seemed to care for himself, keeping his beard trim and his clothes in good order. It was said that he was once an officer in the military. Day after day, McCurry saw him return to this spot and stand there, motionless, without a word, pondering the designs of light on the floor.

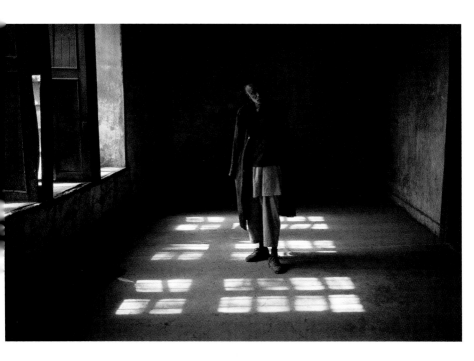

Women at a Shoe Shop, Kabul, Afghanistan, 1992. McCurry was amazed. He couldn't believe his eyes. The chance of seeing five Afghan women together, wearing five differently coloured burkhas, is miniscule, he thought. Seeing the women together in a bazaar, shopping for modern-day sneakers from the West, is even more extra-ordinary. McCurry made the picture. The bonus is the little girl wearing red sneakers on the right – and the woman with red slippers on the left.

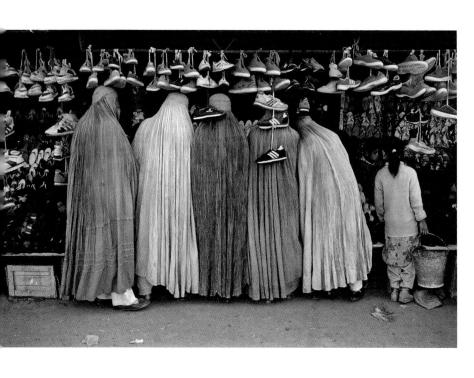

Returning Iranian Refugee, Herat, Afghanistan, 1992. In this dusty, dangerous and destroyed city (page 53), this child carrying her schoolbooks bloomed like a flower in the desert, McCurry remembers. At the time he met her, she and the other people of Herat had suffered for three months under a searing, hot wind that blew dust into everything, and attacked unprotected skin. 'The girl was such a contrast to that harsh environment,' McCurry recalls. 'And notice how her school books have been covered.'

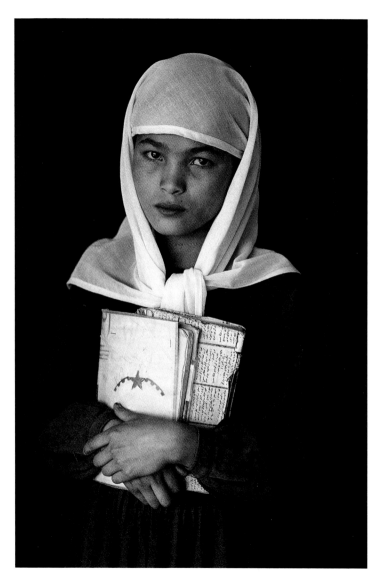

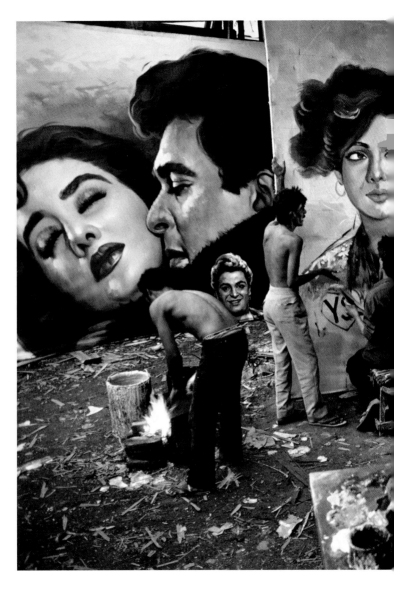

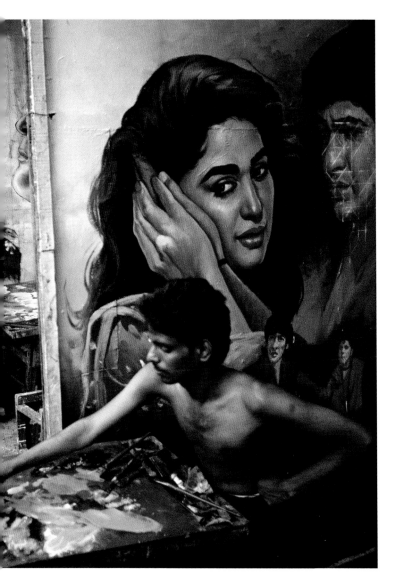

(previous page) Poster Studio, Mumbai, India, 1993. Several layers of reality greeted McCurry as he visited a studio that is a part of the huge movie business in India. It was like a carnival hall of mirrors. The cinema is already at many removes from life. Its actors develop mere fictions of the real thing, which are then recorded upon film and projected in theatres as shadows upon a screen. In this Mumbai studio, artists create additional layers of reality, as they copy photographs developed from the film to make giant poster images of the newest screen siren.

Young Soldier, Kabul, Afghanistan, 1993. During the conflict among warring national factions in Afghanistan that followed the retreat of the occupying Soviet military, city neighbourhoods barricaded themselves against each other. There was no law and little order. This fourteen-year-old was charged with maintaining a barrier along one of the main streets of Kabul, and the boy posed proudly, with a stance and authority well beyond his years.

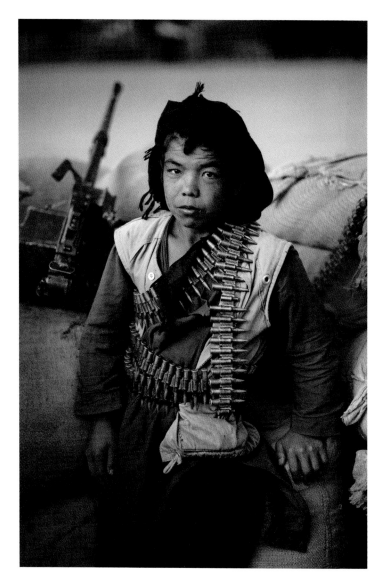

Mother and Child at Car Window, Mumbai, India, 1993. At many a street corne[r] someone appears at a window, asking for help, in every large city, on every continen[t] a woman and child, an outstretched hand, a universal sign of need. And in every cit[y] a barrier separates need from plenty. Here a hand presses against the glass, in th[e] rain, and eyes connect across the barrier.

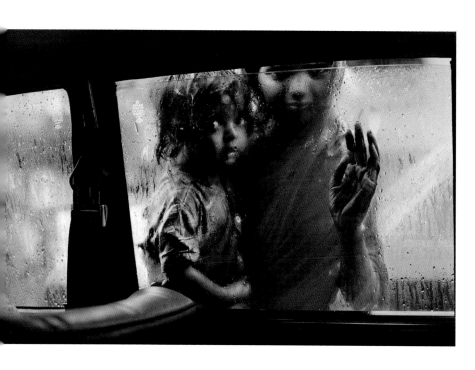

'Food', Rangoon, Burma, 1994. Within the deceptive simplicity of McCurry's image an artful crosstalk of pattern, hue and ideas usually takes place. A snake, which late may become food, shares a table with a patron in this Rangoon restaurant, whil another young man washes his hands and the cook prepares an order. Separatel each element of the image is fairly unremarkable. Together, the irony is deliciou seasoned by the familiar gustatory colour scheme of red and yellow.

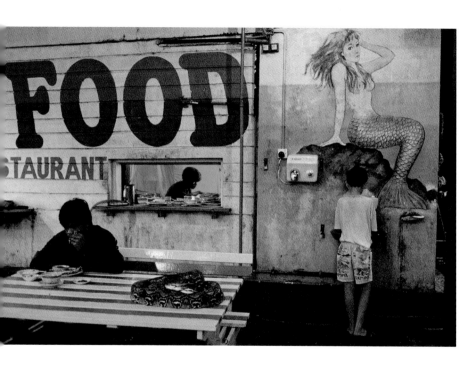

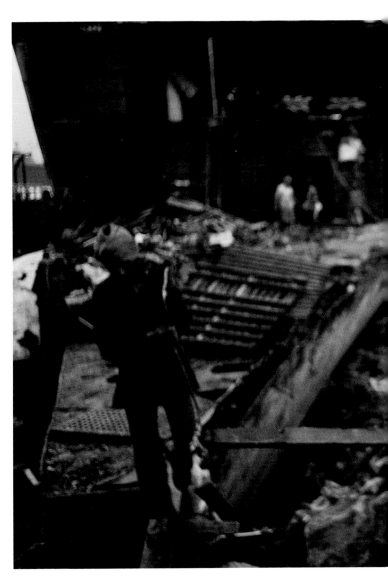

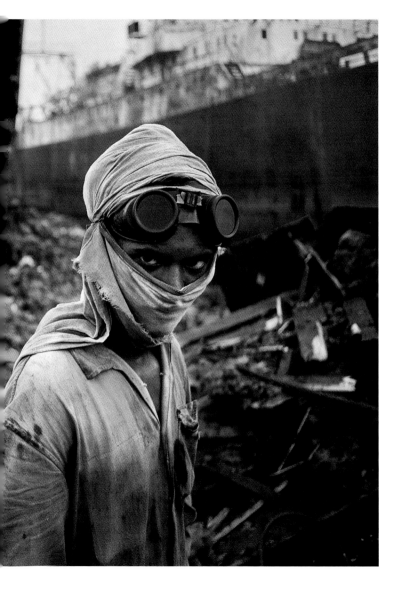

(previous page) Young Welder in a Ship-Breaking Yard, Mumbai, India, 1994. From the tangle of deconstruction in the shipbreaking yard of Mumbai, a young welder stepped forward in 1994 to engage the camera. His eyes, redoubled by the goggles on his forehead, draws our gaze away from the ship's empty hold and we wonder about this young man, whose face we cannot read fully, whose head is protected only by the cloth that covers his mouth. The promise of our gaze meeting, through a photograph, the look of another across time and vastly different spaces is one of the signature strengths of McCurry's art.

Monks Praying at Golden Rock, Kyaikto, Burma, 1994. The Golden Rock is one of the most important Buddhist locations for pilgrimage and prayer. Its precarious balance is a wonder of faith, and legend has it that a string can be drawn through at its base. McCurry spent several days at the site to determine the best vantage point and time to make the exposure. This image was taken about ten minutes after sunset, the sky still rich from the 'golden hour'. The incandescent lights, which illuminate the rock at night, have just been turned on and provide an accent light and shadow on the right.

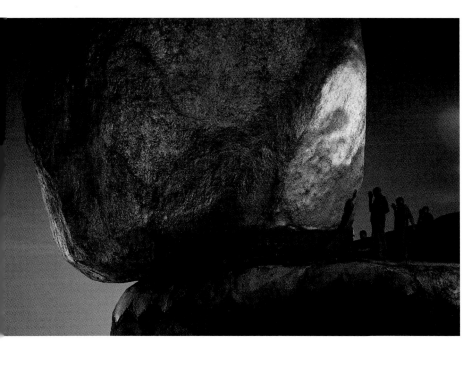

Procession of Nuns, Rangoon, Burma, 1994. Each day these nuns walked a circui around the city. McCurry asked if he could walk with them to make photographs. With their consent, he accompanied them for several days, searching for the best light and location. Even without their presence, this residential area would make a colourfu image. With their presence, McCurry deliberately sought a rainy day in order to have some control over the level of colour in the image. The line of their parasols echoes the yellow horizontal and creates the commentary of an adjacent hue upon the red brick.

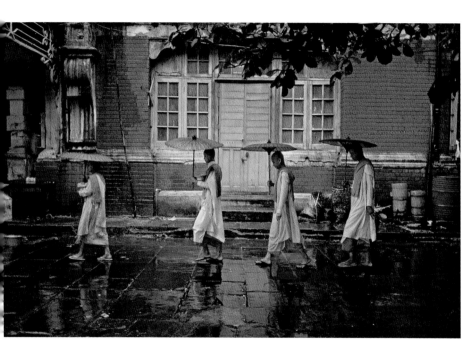

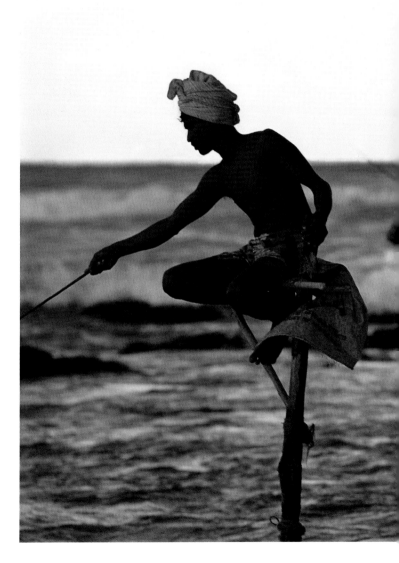

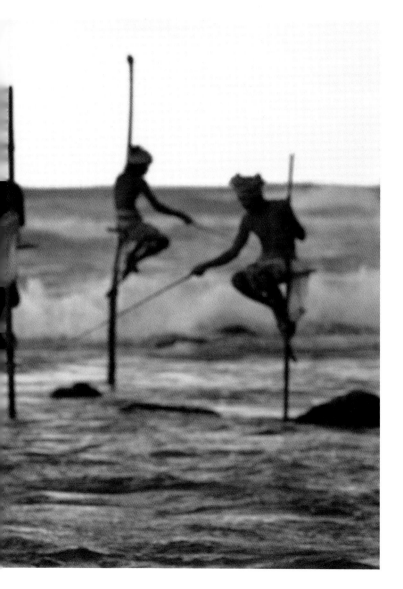

(previous page) **Stilt Fishermen, Weligama, Sri Lanka, 1995.** The theatrical stage would not offer a finer gesture, nor a more exquisite doubling between the near and the far, than does this picture. McCurry captures the beauty of a cultural tradition and with it a natural choreography. This image also preserves a practice now essentially lost to technology, having all but disappeared in the intervening years since the photograph was made.

Widow, Vrindavan, India, 1995. An important part of the experience of this photograph takes place outside the frame. McCurry tells the story in slide lectures about his work. The context of the image, McCurry notes, is a continuation of the dignity and endurance that one surmises from the image itself. The woman in the picture has been a widow for seventy years, her husband dying when she was fourteen years old. Living in a community of widows since that time, she has made a living as one commissioned to pray for others. After he made her picture, the lady invited McCurry for tea. He was impressed that, perhaps because of her prayers to another realm, she lives joyfully, showing no sign of sorrow or resentment.

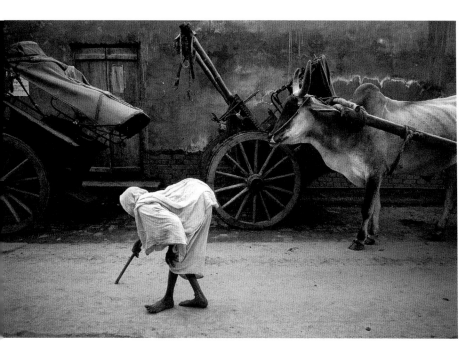

Afghan Fighter, Kabul, Afghanistan, 1995. Life went on here once; families grew, children played and neighbours built a comfortable, middle-class community with one another. And then the fighting destroyed it. And looters carried the remains away – doors, window frames, plumbing, everything. This couch was on its way when McCurry happened by. Life continues in this neighbourhood, but in a different way. Here, a Kabul fighter, who may also be a looter, stretches out for a nap. Twenty-three years earlier, McCurry began his career with a photograph (page 17) of another couch and sleeping man.

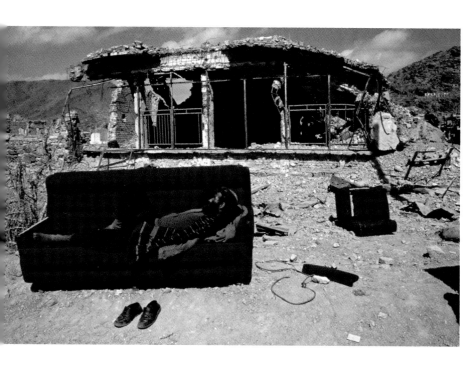

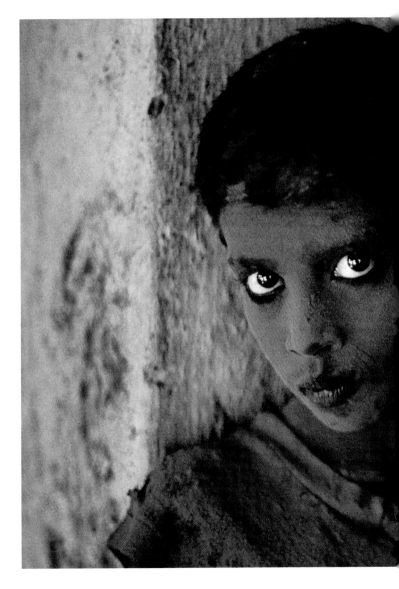

(previous page) Boy at Ganesh Chaturthi Festival, Mumbai, India, 1996. In the midst of the festival of Ganesh, as thousands of people made their way from their homes to the sea, McCurry interrupted a youngster with a request to make his picture. The boy consented, and one reads in his eyes the vulnerability of his acceptance. We see a fragment of festive time, a stilled moment extracted from a noisy, exuberant parade. Yet in that sliver of time, a much larger psychological proposition was created: the boy, framed on the one side by three aggressive slashes of red upon the light face of a pillar; the shadow form of another person at his other side; and the central anchor of his intensely questioning eyes.

Holi Festival, Rajasthan, India, 1996. We wonder what words might have been spoken here on the street in Rajasthan during the Hindu Festival of Holi, which marks the beginning of the summer season. Three men paused to share an idea. What is their secret? What intimacy? What is their history? Their plan? The photograph is silent but the image speaks through its visual language about hidden truths, a furtive whisper and pensive stare – and the passion of the colour red.

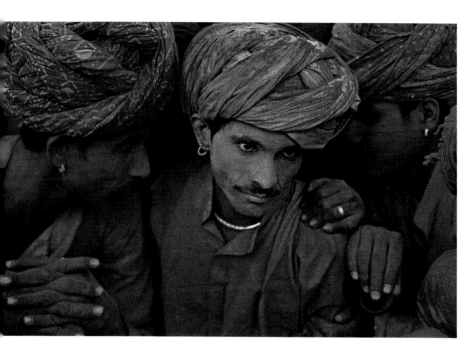

Three Men, Jodhpur, India, 1996. It is a hot afternoon in the Old Quarter, the Brahma section of Jodhpur. Three city workmen wait for their afternoon tea, delivered each day by a street vendor. McCurry discovers these wonderful juxtapositions of colour, shapes and planes during his 'wanderings', long walks during which he focuses attention on the here and now, being fully open to what each moment brings. Here the red jumps out of the blue as if in an abstract painting, yet remains centred within the lives of these three men, patiently awaiting their tea.

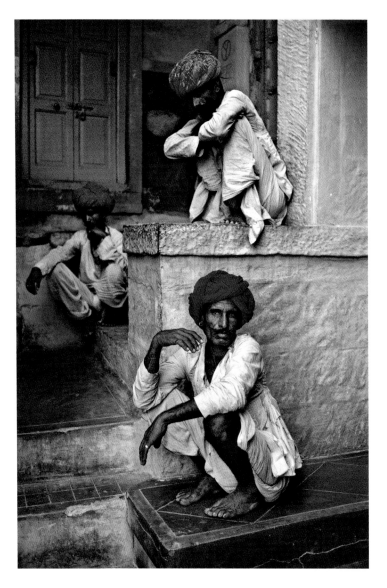

Astrologer, Varanasi, India, 1996. Evening falls along the Ganges in this great Hindu centre and eyes turn toward the holy river. A boy looks across to the other bank and an astrologer and palm reader awaits business, perhaps someone to stay in his little guesthouse. Several million pilgrims visit the numerous shrines and ghats, like this one, along the river each year. McCurry's image is a balance between action and contemplation, just as it creates a give and take between red and blue.

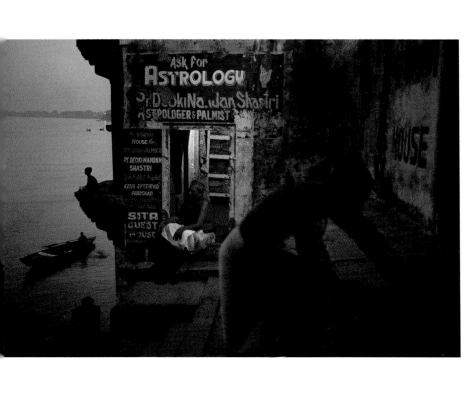

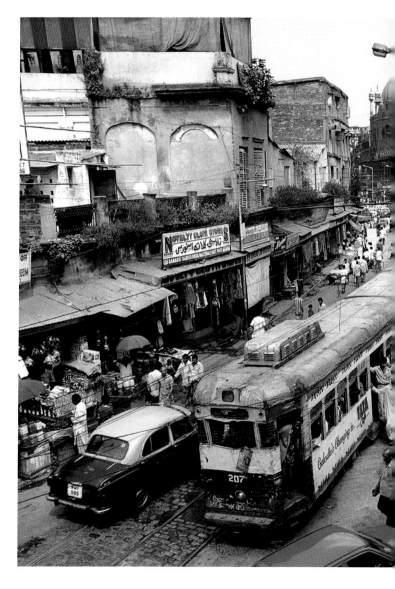

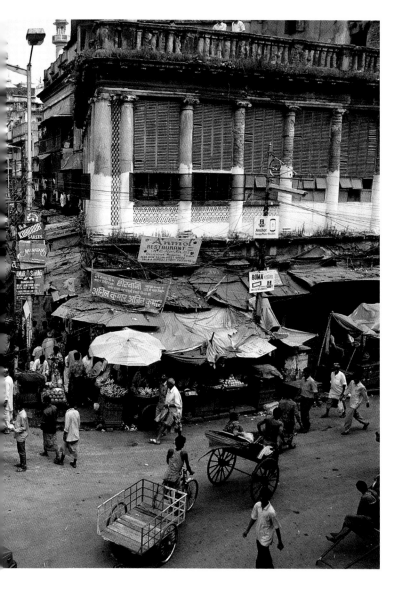

(previous page) A Tram, Calcutta, India, 1996. For McCurry, Calcutta is the most visual city on the planet, spinning with chaos and clutter, crumbling under the weight of its overpopulation, utterly out of control, yet vital and alive. Vendors spill into streets, which hold a confusion of cars, trams, rickshaws, bicycles and pedestrians. So how to make this picture? McCurry looked for an office or apartment on a second floor of a street corner. 'And that is the wonder of the place. Twenty minutes later, I am on a bed in a couple's apartment, making the picture and staying on for a cup of tea.'

Women Working in a Field, Agra, India, 1996. Modest labour is set beside the grandeur of an architectural masterpiece, both in their way symbols of human achievement that reveal a sense of this place and the rich diversity of India. McCurry saw parallels between the doubling and roundness in the domes and in the body language of the two women. He also sensed the fleeting presence of traditional farming. Indeed, this is an image not possible today. The field is no longer cultivated.

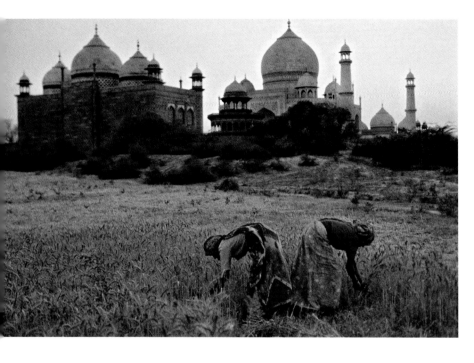

Flower Seller, Dal Lake, Srinagar, Kashmir, 1996. Each morning for two weeks during his 1996 visit to Dal Lake in Kashmir, McCurry travelled with the flower sellers. He had established a ritual for the morning hours, when the sun was at its best. Shortly after dawn, he would begin the day in the market; then he would ride with the boatmen. He knew these were the places for strong pictures. He also knew he needed to work for his pictures, to look and to wait for the right light and action to come together. And then, that morning, from a boat filled with flowers, he caught the boatman's hand in the reflected light of the V of the trees on the lake.

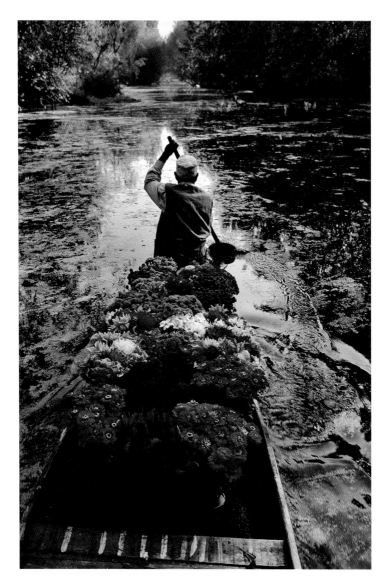

At the Shoemaker, Mumbai, India, 1996. Worlds collide each day in Mumbai, one of India's most successful and most disadvantaged cities. Space, clearly, is at a disadvantage. Four cobblers crowd into a shop no more than a yard deep and several feet high. A young businessman comes to this miniature world on Princess Street for his shoes. This is the clash of cultures that characterizes the transitions of India.

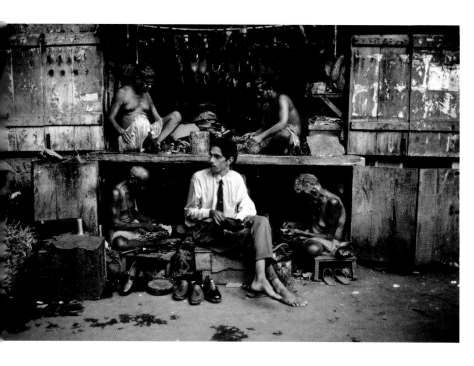

(previous page) Monk Praying, Aranyaprathet, Thailand, 1996. The photograph divides roughly into four quarters, and at the centre, isolated and back-lit against a darkened background, is a monk at prayer. His shadow is cast forward into one of the quarters. Occupying another of the quarters is a black cat, pointing toward the monk, who reads a Buddhist scripture. It is a story of quiet contemplation. McCurry has visited Thailand frequently, and published his visits to Buddhist monasteries in *The Path to Buddha: A Tibetan Pilgrimage* (2003).

Sleeping with Snake, Tonle Sap, Cambodia, 1998. This picture needs a caption. Without it, we might assume the snake threatens the sleeping woman and her child. But, in fact, sleeping with snakes – and with birds, and monkeys, and an alligator – is a matter of course for this family. Living in a houseboat, the family offers their menagerie as an opportunity for tourists – to observe and to photograph.

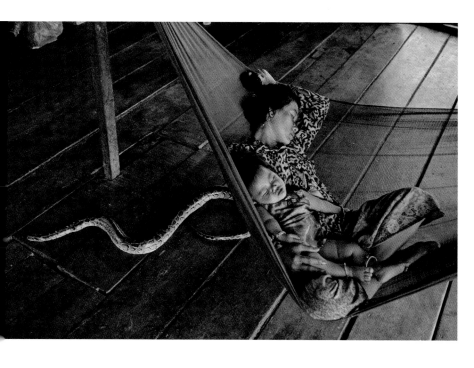

Nomad Woman, Kham Province, Tibet, 1999. This is home for the nomad woman, and these are her things — her ladles, pots, bowl and cloths. This kitchen centres life both for her and for her family. A hole in the roof of the tent permits light and frees the smoke. There were a dozen tents in this highland village, where the community grazed their yaks in the warm season. McCurry carefully visited each tent and asked for permission to photograph, so as not to give offence or to slight anyone. This woman, on being asked for permission, disappeared for several moments and returned with the hat and shawl she wears here and the bowl she hold in her hands.

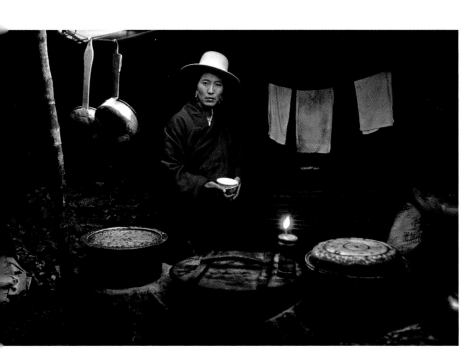

Young Monks in the Rain, Angkor Wat, Cambodia, 1999. Four monks make their way to prayer on a rainy day at Angkor Wat. As it was raining, the walkway, usually crowded with tourists, is empty, the way to the temple clear of distraction. McCurry structures a heightened awareness for the viewer by discovering the subtle patterns the monks create through their positions on the path — two near and two at a distance, their robes alternating in colour, and their arrangement in space echoing the shape of the temple spires at the end of a dramatic vanishing point.

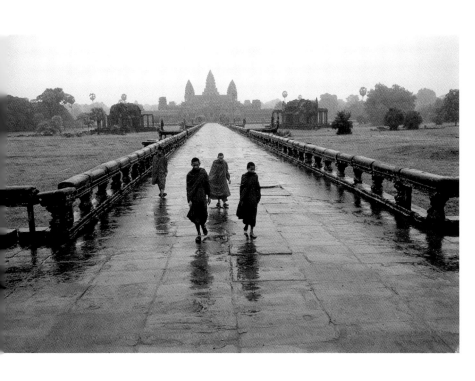

Women Gathering Clover, Shibam, Yemen, 1999. Six women with traditional hat gather clover in the fields of valleys, cut by seasonal waterfalls out of the rough arid mountains of this tiny Asian nation on the Arabian Peninsula. Like the country itself this photograph is a study of contrast, the fertile against the arid, the traditiona against the newly built houses, the green of vegetation against the earthen tones o rock and buildings. The six straw hats create an animated dance in the foreground.

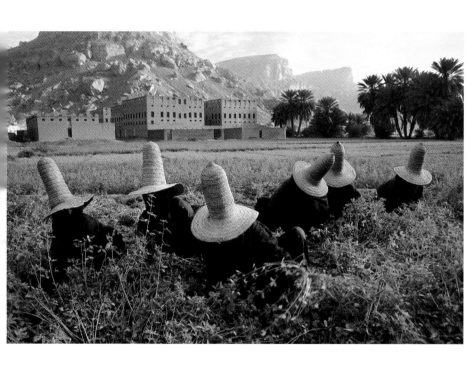

Monk at Jokhang Temple, Lhasa, Tibet, 2000. The lines of time trace a deep persona[l] history across this old monk's face. It seems as though his has been a life of enquir[y], a quest for a truth, on a higher level. He looks into the lens of the camera with [a] searching gaze. That is what attracted McCurry, as he visited the Jokhang Templ[e] on his photographic pilgrimage through Tibet, sketching with his camera the variou[s] pathways to the Buddha. 'There was something about his face, an ancient feelin[g], some kind of ancient truth there. I have never seen a face quite like his.'

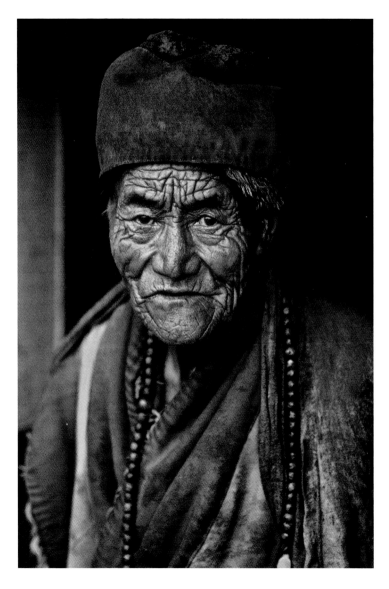

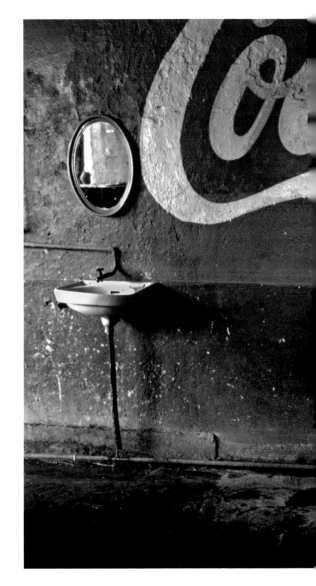

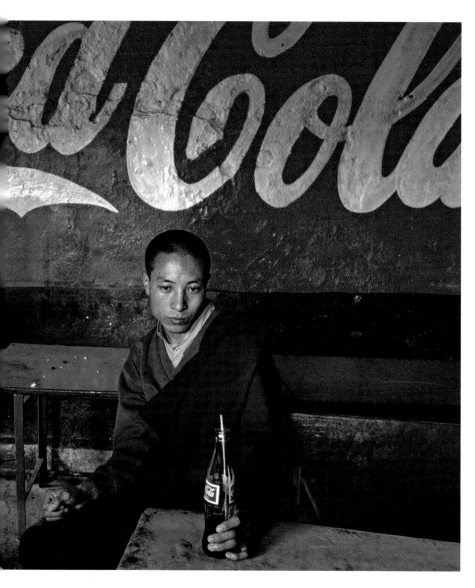

(previous page) Young Monk in a Teashop, Bodh Gaya, India, 2000. This is not the contemplative environment one expects to find on a search for pathways to Buddha in India. Instead, it appears as a study in alienation. A naked wash basin and ill-placed mirror butt up against the weathered logo of a transnational soft-drink corporation, framing a young monk's unfocused look, his fist clenched, a partially finished bottle of Coke in his other hand. 'The picture is about body language,' said McCurry. 'And the light was just right. The sun was hidden behind clouds.'

Young Monk with Flowers, Larung Gar, Kham, Tibet, 2000. McCurry's camera stopped a young monk on his way to prayer, his reverie arrested by what must have been a strange interaction with a photographer from another world. Could he have imagined – does he now? – the tens of thousands of eyes beyond the picture plane which have met his own? Could McCurry have known as he took the picture the eternity it suggests, summarized by the chain of beads the young monk carries, the symbols of infinity that surround him, and the young man's intentions for the bouquet he carries to present to the Buddha?

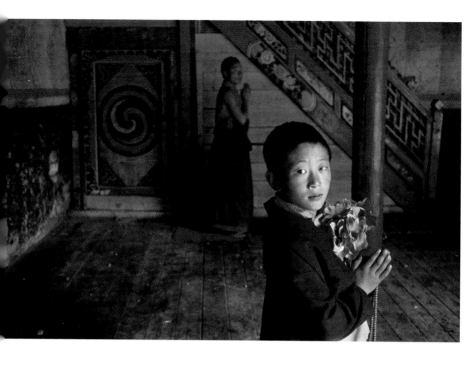

Pilgrims at Larung Gar, Kham, Tibet, 2001. 'I could feel the devotion and the intensity of the man,' McCurry recalls of his trip to the Buddhist academy, Larung Gar. 'I noticed how he clutched his prayer beads, and I saw his fingertips, blackened by paint, or a polish, or disease.' The picture is a dazzle of colour, alive with the contrast of reds and greens, and pulsing with detail and pattern. The intensity of the focused figure emerges from this heightened awareness.

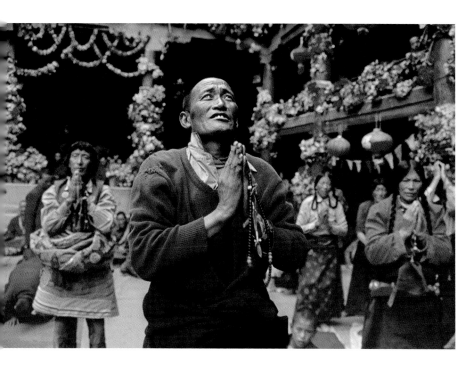

Girl in a Chinese Coat, Xigaze, Tibet, 2001. The irony of a young Tibetan girl i a Chinese coat attracted McCurry to this picture. The coat seemed evidence of new merging cultures, once separated by a gulf of hatred and distrust. The youngste shines with pleasure over her new coat, and she wears it with a splash of styl a scarf tossed around her shoulders, rouge and lipstick colouring her face. McCurr adopts a close focus, so that any distracting context blurs while her colourfu pleasure remains in sharp focus.

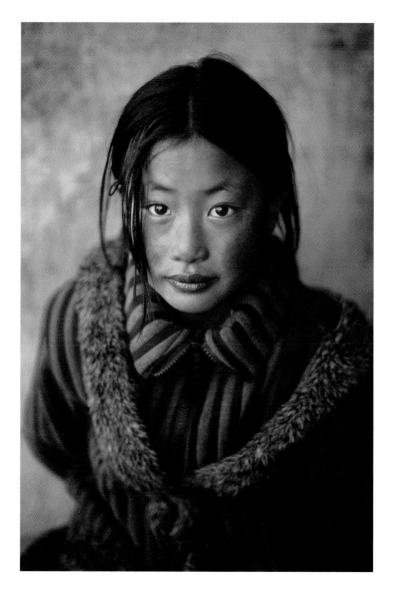

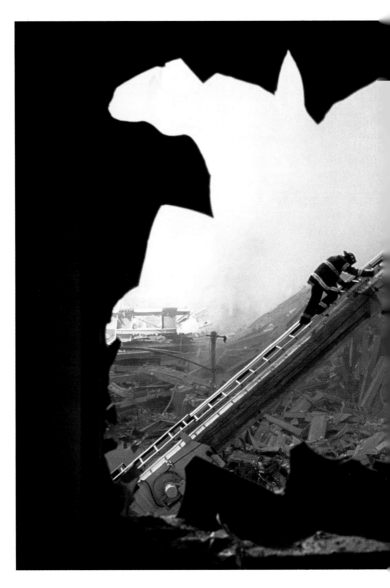

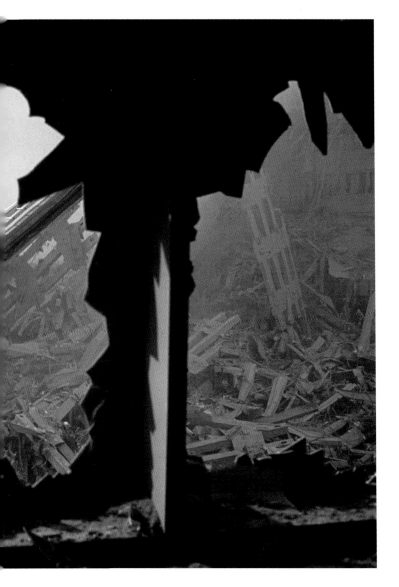

(previous page) Fireman, World Trade Center, New York, 2001. A shattered, darkened glass window frames the hard sight of a fireman climbing up the face of rubble that once was a tower of the World Trade Center. McCurry had returned home the day before from an assignment in Tibet. Hearing the disaster from his apartment, ten blocks away, he grabbed his camera and hastened to the site. His pictures, and those of his Magnum colleagues, were later exhibited at the New York Historical Society.

Beggar and Shadow, Kabul, Afghanistan, 2002. At one time, one would never have seen a woman – or child – begging in Kabul, McCurry notes. The wars have cast long shadows. Beggars, mostly widows and orphans, now collect in the nooks outside the mosques in Kabul. Her face hidden, her garment flowing out of the shadows, this woman cuts an ominous figure in the sliver of light from which she begs support.

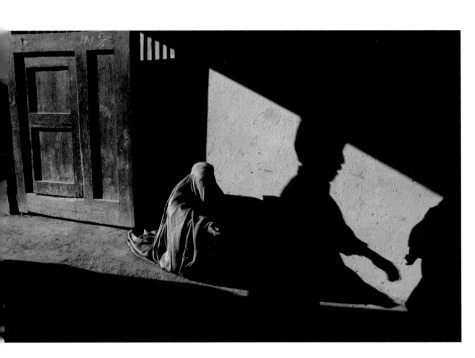

Landscape with Horse, Band-e Amir, Afghanistan, 2002. High in the cold mountains of Afghanistan, a colt runs after its mother, set against the dramatic backdrop of a pristine lake few have seen. The scene in this distant place seems primal. But the natural rock formations at the edge of the cliff assert a strange presence here. McCurry's mind is taken back to the twin towers of the World Trade Center, and the irony of their echo here in Afghanistan.

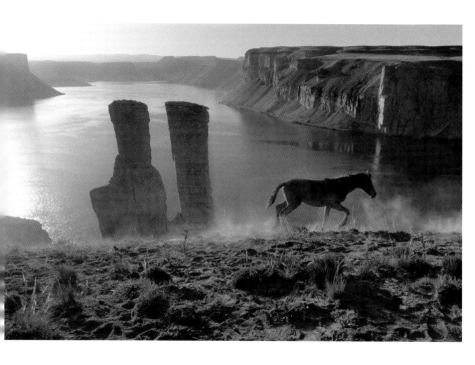

Coal Miner, Pol-e Khomri, Afghanistan, 2002. A coal miner, dark with the dust from the mine, slowly registers his presence against the darker field of the mine's deep shaft in central Afghanistan. Light from his lamp and the trail of white smoke from his cigarette focus attention. Then the whites of his eyes emerge, then his fingertips. Gradually he appears. This difficult image mirrors the tough lives of miners in Afghanistan, men who live perilously under threatening conditions.

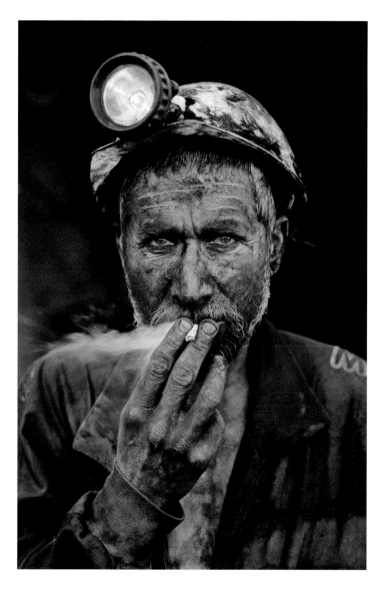

Hands, La Fortuna, Honduras, 2004. Against a wall surrealistically covered with stencils of hands, a cowboy's big hands hold a little girl. The man, who is the girl's grandfather, is lost in thought, his face hidden in the shadow of his hat. The girl looks out toward the photographer, and through him to his audience, seeking a connection, it appears, though the man clasps her in a firm grip. The picture can stand for the process of bridging cultures – the young, eagerly looking out; the older generation holding fast.

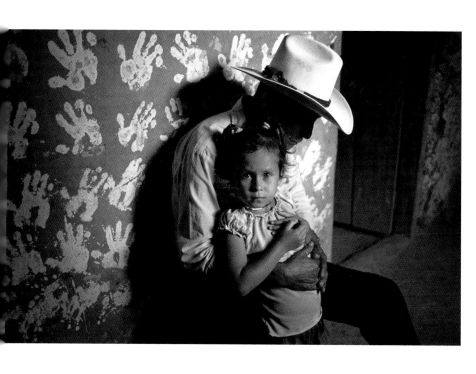

1950 Born in Philadelphia, USA.

1971 McCurry studies History and Cinematography at College of Arts and Architecture, Pennsylvania State University.

1972 McCurry's photographs are exhibited in a group show, *Envisions*, at the university's Zoller Gallery.

1974 Leaves for India to work freelance. McCurry firsts starts using colour film.

1979 Enters rebel-controlled Afghanistan in May, prior to the Russian invasion. McCurry's images are among the first to document the conflict there.

1980 Covers the war in Afghanistan for *Time* magazine, for which he is awarded the Robert Capa Gold Medal.

1982 Covers conflict in Beirut for *National Geographic*. Work is exhibited in *Afghanistan Today: The Will To Survive*, SoHo Photo Gallery, New York.

1984 Takes portrait of Sharbat Gula, the 'Afghan girl' while on assignment for *National Geographic*; receives Magazine Photographer of the Year award from the National Press Photographers' Association.

1985 *The Imperial Way* is published; in Iraq on assignment covering Iran-Iraq war; wins four first prizes in the World Press Photographers competition and the Olivier Rebbot Memorial Award.

1986 Receives second Olivier Rebbot Memorial Award for work in the Philippines.

1987 Receives Medal of Honor from the Philippines for coverage of the 1986 Philippine Revolution.

1988 *Monsoon* is published; travels to Angkor Wat, Cambodia, for the first time.

1989 Covers disintegration of former Yugoslavia and survives a plane crash whilst taking aerial photographs over Lake Bled in Slovenia.

1990 Wins White House News Photographers Association Award of Excellence.

1991 On assignment in Kuwait and Iraq to cover the Gulf War.

1992 McCurry records the rebuilding of Afghanistan after war and joins Magnum Photo Agency as full member.

1995 Meets Nobel Peace Prize winner Aung San Suu Kyi in Burma.

1998 Granted the Eisenstaedt Award.

1999 Receives Pennsylvania State University Distinguished Alumni Award and is made Pennsylvania State Fellow; covers assignments in India, Sri Lanka and Thailand; *Portraits* (Phaidon Press) is published.

2001 McCurry returns from an assignment in Tibet on 10 September and covers events at the World Trade Center on 11 September, New York.

2002 *Sanctuary: The Temples of Angkor* (Phaidon Press) is published; *Search for the Afghan Girl*, a film made by Lawrence Cumbo with McCurry, wins the Gold Prize for Documentary at the 2003 New York Film Festival.

2003 Touring solo show, 'Face of Asia', is organized by George Eastman House, Rochester, New York. *The Path to Buddha* (Phaidon Press) is published.

2004 Travels to Auschwitz on assignment for *National Geographic*.

2005 McCurry receives an Honorary Fellowship from the Royal Photographic Society of Great Britain.

2006 *Looking East* (Phaidon Press) is published. McCurry receives awards from Lowell Thomas Travel Journalism Competition; the National Press Photographers Association; and an Honorary Fellowship from the New Zealand Institute of Professional Photography.

2007 *In the Shadows of Mountains* (Phaidon Press) is published. McCurry's work is exhibited at *India at 60*, New York; *South Southeast*, Rennes, France; and *Tibet*, International Centre of Tibet, Washington DC.

2009 *The Unguarded Moment* (Phaidon Press) is published. McCurry receives the Ambrogino D'Oro from the city of Milan, Italy.

2010 A major retrospective exhibition is held at the Galleria Nazionale dell'Umbria, Perugia, Italy, and work is exhibited throughout Europe.

2011 The large-format, limited edition of *Steve McCurry: The Iconic Photographs* (Phaidon Press) is published.